An Introduction to

Brass

An Introduction to

Brass

Eric Turner

Senior Museum Assistant, Department of Metalwork
Victoria & Albert Museum

LONDON: HER MAJESTY'S STATIONERY OFFICE

To my Mother and Father

Edited by Anthony Burton
Designed by Andrew Shoolbred
to a series design by Humphrey Stone
Printed in Great Britain by W. S. Cowell Limited, Ipswich

ISBN 0 11 290376 2
Dd 696397 C46

Brass is an alloy of copper and zinc. The modern definition of the word specifically means an alloy of two parts pure copper to one part pure zinc. Copper is mined in its natural state and it is a relatively simple procedure to remove any impurities found in the ore. Zinc, however, is mined as calamine, a yellowish ore which is a carbonate of zinc. The isolation of zinc from its carbonate is extremely difficult and consequently pure zinc is a comparatively modern product in Western Europe. The process described by Theophilus, in his treatise *De Diversis Artibus* written in in the first half of the 12th century, is worth recounting here in some detail since the method of manufacture remained substantially unaltered for several centuries.

The calamine ore is crushed and mixed with powdered coal. It is then heated until it is red hot and placed in a crucible until this is approximately one sixth full. On top of the calamine and coal is placed red hot copper ore, and the mixture is covered with more coal. The crucible itself is designed to allow air to pass freely through the mixture while it is being smelted. It is essential that the vents remain unobstructed throughout the process and from time to time it is necessary to poke the openings with a thin hooked rod so that they do not become accidentally blocked with residue.

Once the mixture is completely melted, it is stirred by means of an iron rod until the calamine is thoroughly mixed with the copper. It is periodically topped up with more calamine and the mixture is kept in flux for approximately nine hours. The crucible is then removed from the fire with tongs and allowed to stand for a further hour, after which the molten alloy is poured into trenches and allowed to solidify. The alloy is then brass.

This method of manufacture effectively smelted the calamine at the same time that it fused the copper with the zinc. Good quality calamine could contain 52% zinc, but the quality varied enormously, and it was not possible to determine the proportion of pure zinc in each sample of ore until the process of manufacture was complete. Thus this traditional method of manufac-

turing brass did not allow for the precise regulation of the proportions of the constituent metals used. Since the colour of brass is determined by the quantity of zinc present the appearance of old brass varies enormously. If the proportion of zinc to copper is as low as 7–14%, the colour of the alloy will be distinctly reddish. If it is roughly 30%, the alloy will be a golden colour. The greater the quantity of zinc used, the paler the colour will be, until eventually, if the alloy contains 80% zinc, the alloy will be the colour of zinc itself.

It was not until the mid-17th century that the chemical structure of calamine was properly understood and it was discovered that it was the zinc constituent which fused with the copper to give the alloy its character and colour. The production of zinc was established in the East well before it was carried on in Europe, and zinc was imported in commercial quantities from the East Indies from the early 18th century onwards. The first European to extract zinc from its ore was probably Henkel who eventually published his results, but not the procedure, in 1741. Experiments were carried out elsewhere and the first smelting took place in England in about 1730; even then it was only on a very small scale until 1743 when Champion, who had patented his process five years previously, established his works in Bristol with an annual output of about 200 tons. The first Continental zinc foundry was established at Liège in 1807.

Thus it was only from the mid-18th century onwards, when it became possible to control precisely the proportions of the constituent metals in the manufacture of brass, that a strict definition of the alloy, based on standard proportions of copper and zinc, became accepted. Hitherto, brass had a much broader meaning, covering alloys which contained copper and zinc in varying proportions and which may have included other trace elements as well, such as tin, antimony and lead. These other elements were included in the alloy because the copper ore was seldom refined before being added to the crucible containing calamine during manufacture.

The situation is further confused by the well established practice amongst medieval and later brass founders of adding redundant or damaged brass articles to the molten ores during the smelting process. This inevitably changed the composition of alloy from one smelting to the next.

The modern use of the word bronze also only dates from the 18th century. Nowadays the distinction between bronze and brass is one of composition whereas for Theophilus it was one of purpose. In the concluding paragraph to his section on the manufacture of brass, and in the section immediately following it, he states clearly that bronze was merely a form of brass alloy which contained copper that had been refined before smelting. Refined copper was used because it was necessary to remove

any trace of lead from the copper ore, if the alloy was ultimately to be gilded: otherwise the gold would not properly adhere to the surface of the base-metal. Thus bronze simply referred to high quality articles fashioned from brass, which were intended for either ecclesiastical use or the luxury market. Even as late as 1755, Dr Johnson gives two meanings to the word 'bronze' in his *Dictionary*. The first is 'brass', and the second is 'relief or statue cast in brass'. Because of the imprecision in the early usage of the words brass and bronze, this survey includes articles which would nowadays be properly described as bronze or even copper.

Although Theophilus, in his description of brass manufacture, does not specify the relative quantities of each metal used, later authors do. Christoph Weigel in his *Abbildung der Gemeinnütz-lichen Haupstände bis auf alle Künstler und Handwerker* (Compendium of the main professions useful to the common good, all artists and craftsmen being herein included), published in Regensburg, 1698, goes into greater technical detail. He states that in each smelt 28 pounds of copper was added to 100 pounds of calamine and that overall 23,000 cwt copper added to 40–50,000 cwt calamine produced 35,000 cwt brass. William Richardson demonstrates another ratio for a different quality of calamine ore. In *The Chemical Principles of the Metallic Arts*, 1790, he states: 'From 60 lbs of good calamine, and 40 lbs of copper, 60 lbs of brass may be obtained'.

From these accounts, it is clear that during manufacture a much greater quantity of calamine was consumed than of copper ore and that, therefore, the brass-producing centres needed to be situated close to plentiful sources of calamine. The brass industry in Europe during the Middle Ages was concentrated in the area between the Meuse and the Rhine, where the most important deposits of calamine lie. The main centres of production were the Attenberg and Holberg mines, both near Aachen, and Kornelimünster and Gressenich which lie between Givet and Liège. The two latter mines were the principal sources of supply for the town of Dinant which was the biggest centre of brass production until the town was sacked by the Duke of Burgundy in 1466. Refugee brass workers found their way to neighbouring towns such as Brussels, Namur and Malines. Brass production in Nuremberg and Aachen assumed greater importance after the decline of Dinant.

The gradual urbanization of small market and monastic towns throughout the early Middle Ages was accompanied by an increasingly sophisticated system of municipal politics. A major influence on this was the growth of the guild system. Craft guilds began to make their appearance in the first half of the 14th century, and by the 15th century their political and economic significance was considerable.

The basic principles of the guild system were shaped by practical considerations. Regulations were designed to control both the quality and the quantity of a craftsman's output, for the maintenance of strict standards was essential for the survival of the craft itself. The training of apprentices was closely supervised and subsequent entry to the rank of master was competitive. The quality of raw materials used was precisely stipulated and there were even regulations governing the use of tools in each trade.

Competition was restricted so that each craftsmen could enjoy a reasonable standard of living as was appropriate to his status. Master craftsmen were limited in the number of employees that they could have in their workshops and working hours were confined to daylight. Pricing policies were formulated and each craftsman was restricted to producing only a limited range of wares. For example basin makers were prohibited from producing mortars since each required a different set of skills. Penalties were usually severe and swiftly applied to any member who flouted the rules. Thus trade and commerce were governed by an authoritarian and hierarchical system. The guild system by its own structure was inherently conservative, jealously guarding the privileges it had established for itself, and it discouraged technical innovation for fear that a decline in standards would ensue. By the 18th century this approach was becoming archaic. The French Revolution of 1789, followed by Napoleon's régime and the Industrial Revolution of the 19th century finally eradicated the system entirely.

The city of Nuremberg was unique in that its trades were not grouped into guilds but were administered by the town council. This was composed of members of a select group of powerful mercantile families and so decisions affecting trade were made with far less impartiality than elsewhere. In 1348–9 the craftsmen of Nuremberg rebelled and attempted to introduce a guild system, but were unsuccessful. Thus control remained with the merchants or distributors rather than the producers, the craftsmen themselves. This system fostered an early form of capitalism which made Nuremberg in the 16th century the most important centre in Europe for the metalworking trades. Therefore it is worth studying the Nuremberg metalworkers, and the craft of the basin beaters in particular, as their pre-eminence was undisputed.

Theirs was a free trade until 1493 when the Nuremberg council considered it important enough to elevate its status. Regulations were enacted which incorporated some of the principles of the traditional guild system elsewhere. Only a limited number of craftsmen could enter so that competition could be controlled and standards maintained. Moreover, only Nuremberg citizens could apply and, once accepted, were prohibited from

emigrating to neighbouring towns. This had a twofold advantage. The craftsmen remained under the jurisdiction of the town council at all times, and trade secrets were not disseminated. These regulations remained in force for the following century and Nuremberg gradually consolidated its monopoly in basin production.

Unlike the traditional brass-producing centres, in Dinant, Aachen and Lower Saxony, Nuremberg was not conveniently situated near supplies of either calamine or copper. The essential raw materials had to be imported and it was only members of the large trading houses who could provide the necessary working capital to do so. Moreover, the merchants had control over the transportation routes across Europe, and the export markets. Inevitably their interests began to influence the conduct of the trade itself.

In the Nuremberg archives there is a regulation dated 1535 which stipulates that basin beaters were forbidden from purchasing cast brass, but were required to smelt and cast it themselves. The sheer magnitude of basin production at this period would suggest, nonetheless, that this regulation was consistently ignored. Sheet brass could be purchased cheaply and easily from foundries which had water driven equipment to beat the cast ingots into flat sheets. This itself required heavy capital investment which was only possible through the trading houses.

The production process from then on required skilled labour. The sheet was cut approximately to size, and then roughly shaped with a hammer over an anvil. At this stage a horizontal rim was made, and the object was trimmed to size on a lathe. The design of the lathe was one of the closely guarded secrets of the Nuremberg town council.

The decoration was then applied, usually to the reverse side of the metal, by iron punches specially rounded to avoid cutting into the soft metal. In addition a sheet of lead was placed between the bowl and the anvil in order to avoid scarring. Repeated motifs around the edges could be swiftly applied. Embossing free-hand was never popular among Nuremberg craftsmen and so the scenes that often decorated the bottom of bowls were also created by a series of metal stamps.

The earlier basins adopted a form which had been popular since medieval times. The diameter was never very large and the rims correspondingly deep. The whole of the inside bottom was covered with relief decoration. The subject matter usually fell into three categories. There were scenes from classical antiquity, themes from the Old or New Testament, or allegorical figures personifying vices and virtues. Towards the end of the 15th century, worldly motifs began to appear such as a pelican with its young (symbolizing maternal love) or a stag at bay, (the hunt).

By the early 16th century, the dishes became greater in diameter, the depressions shallower and the flanges of the rims correspondingly wider. Pictorial themes still continued to be used in decoration but the wider bases afforded scope for an increasing use of abstract decoration. A central motif might be bounded by one or two concentric bands of decoration of either interlaced scroll-like waves or lettering. This was not necessarily embossed with punches in the traditional manner but was often cast in the mould at an earlier stage of manufacture. The inscriptions themselves were usually meaningless, and merely incorporated into the overall design for their decorative value.

The production of brass bowls was not exclusive to Nuremberg and what has been said about basin production there applies equally to other centres of brass production such as Dinant, and its immediate neighbourhood, from Bouvignes to Aachen. Despite the secrecy surrounding the trade in Nuremberg, techniques and styles were copied with equal facility elsewhere, so that nowadays it is difficult to assign a place of manufacture within Northern Europe to any dish produced during this period. The dispersal of refugee craftsmen, after the downfall of Dinant in 1466, is one reason for this, quite apart from the fact that dishes exported provided prototypes for others to follow.

Those exported to England were sometimes used as alms dishes. Elsewhere their function was primarily secular. European paintings of domestic interiors show that they were frequently used purely for ornament in the homes of the rich bourgeoisie. Otherwise they were used in conjunction with lavabos or ewers, also in brass, for washing hands after a meal. Before the 17th century, when forks became customary, such equipment was essential to any dining table. Few brass ewers have survived. Those that have are generally set on a tall circular pedestal supporting a squat globular body, out of which rises a long slender neck. The lid is usually dome shaped, while the handles and front are cast in the forms of mythical creatures.

The lavabo, in use since 1400, was favoured in middle class households. It was shaped like a pot with two curving tubular spouts, often moulded in the form of the head (with open jaws) of some fabulous creature. The vessel itself was suspended from a free swinging hook above a basin of beaten brass. In order to use it, one tilted it slightly sideways and a trickle of water would flow. It was very economical in use, since as soon as it was released, it would swing back to its original upright position. Lavabos continued in use until the 17th or 18th centuries, when they were replaced by wall cisterns in faience, pewter and very occasionally brass.

In Venice, the production of brass dishes flourished in the first half of the 16th century. They were very elaborately dec-

orated but not with traditional European linear ornamentation. Venice during this period traded, and fought, extensively with the Turkish and Arab empires which bordered the Mediterranean basin. Thus Venetian merchants brought back to the city Near Eastern craftsmen and goods that had an immediate influence on the indigenous population, and eventually the rest of Europe. The Venetian Moslem community produced many splendid damascened brass vessels, some of which are signed in Arabic by their makers.

Unlike their Northern European counterparts, the vessels were always engraved and inlaid with silver. The decoration was more extensive, often covering the entire surface of an object. The arabesque pattern, based on a stylized plant with a winding stem, was studied and copied by contemporary Italian artists. By the middle of the 16th century, the arabesque as a form of ornament was beginning to influence craftsmen all over Europe, and became incorporated into the development of European ornamental design, until the decline of the Rococo in the late 18th century.

An early example of ornament developing from the arabesque is the interlaced strapwork borders on dishes engraved by Italian craftsmen. However they seldom adopted the silver inlay which was characteristic of the Saracen artists.

The standard of engraving was particularly high amongst both immigrants and local craftsmen. The rate of production was slow, and every basin is evidence of extreme skill and attention. Consequently such vessels are rare, and the frequent appearance of a coat of arms on those that remain would suggest an aristocratic patronage.

The decline of Nuremberg was hastened by the Spanish occupations of Antwerp in 1576 and 1585. Antwerp was the principal port for the North German towns, out of which brass was shipped to France, England, Spain, Portugal and the Baltic countries. The taxes enacted by the Spaniards crippled commerce, and the brass trade transferred to the northern half of the Netherlands, particularly the ports of Rotterdam and Amsterdam.

The English brass trade began in the reign of Elizabeth I. Her ambition was to establish an acceptable level of political and commercial self-sufficiency in her kingdom. Thus she encouraged foreign craftsmen to emigrate and settle in England. In 1565 she granted by patent the rights to mine all the calamine in England to her assay master William Humphrey and a German, Christopher Schulz. At the same time they also secured exclusive rights to manufacture all brasswork in England, and in 1568 thus formed 'The Society for the Mineral and Battery

Works'. The venture was not very successful. The difficulties of mining suitably graded ore and the competition of imported wares from Northern Germany proved to be major obstacles. The Thirty Years War, from 1618 to 1648, provided the first real stimulus to the English brasswork industry. Imports became restricted, and refugees from Northern Europe fled to England and settled.

The history of the brass trade from the 17th century onwards is difficult to chart. In Europe, it never recovered the stature it had enjoyed in the North German cities from the 14th to the 16th centuries. The Thirty Years War severely impaired trade and commerce throughout Europe. France was the only political and financial beneficiary. For a while, the brass founders flourished in France, stimulated by a war economy. However, once the war was over and trade generally revived throughout Europe, the brass founders found themselves in increasing competition with the silversmiths. Silver, from Central and South America, had begun to be imported from as early as the 16th century. Supplies from this source were relatively abundant and the increasing size of the merchant navies of both Britain and Holland, over the next two centuries, meant that the metal became readily available. The price for silver dropped dramatically and many people, who hitherto had not been able to afford it, could now buy silver tableware.

Another source of competition was the Far East. Porcelain and faience were being imported in considerable quantities by the Dutch East India Company and undermining markets which had been traditionally reserved for the brass founders.

The overall standard of the craft inevitably declined. Brass producers were forced to appeal to cheaper markets, and in this Birmingham succeeded admirably.

Birmingham was particularly attractive to immigrants despite its poor location. It was remote both from the raw materials it required and from commercial outlets for its manufactured goods. However, it placed few restrictions on trade and escaped religious persecution. The city had no corporate status and sent no one to Parliament. Therefore its citizens were unaffected by such laws as the Act of Uniformity of 1662 and the Five Mile Act of 1665. The expansion of the population from the mid-17th century onwards was remarkable, and closely corresponded to the growth in the metalworking trades. In 1650, it numbered merely 5,472. By 1741 it had risen to 24,660. Forty years later it had doubled and was 50,295.

Iron was the material traditionally worked in Birmingham, and the iron-worker's skills were not radically different from those required for the working of brass. Thus after the introduction of brass-working in the late 17th century the town's

industrial output expanded rapidly. This coincided with an increased demand in the Restoration period for expensive novelties and trinkets, buttons and buckles and all sorts of filigree work. The demand for Birmingham hardware was further stimulated by legislation, introduced in 1662, which banned the importation of foreign buttons, and by further laws in 1688 which prohibited all trade with France, the principal source of supply for luxury goods in the 17th century.

The producers of light metal objects thrived in this protected market. Their manufacturing skills, combined with low production costs, overcame the town's remoteness from its raw materials and its markets. Labour was organized on a piece-work basis. Though this in itself was nothing new, the extent to which it was applied was. It was obviously more efficient for one craftsman to concentrate on a detail, applied repeatedly to a range of objects, than to fashion an entire object which may have required a varied range of unequally mastered skills. Mechanization further improved industrial efficiency. Birmingham manufacturers had a reputation as entrepreneurs, having a lively interest in science and technology and the practical application of new ideas. Mechanical rolling and die-stamping were widely practised, motor power being at first provided by water. Perhaps the most famous example of mechanical advance in Birmingham was the development of the steam engine, by the partnership of James Watt and Matthew Boulton. This decisively revolutionized the manufacturing trades and led to the great industrial expansion of the 19th century.

Although Boulton is principally famous for his collaboration with James Watt, he joined his father's hardware manufactory in 1742 at the age of 14. In 1759 the elder Boulton died and his son assumed control of the business. It is not clear how large the business was at this time, but it was exporting goods to the Continent before 1750. Thus Matthew Boulton must have inherited an already flourishing concern. It was his ambition to become the principal manufacturer in Birmingham, (particularly in ormolu, where he could try to break the French monopoly).

In this he was only partially successful. Nevertheless he was, as one of his friends described him, a born promoter. In the latter part of his life, apart from his outstanding success with the steam engine, he successfully initiated a flourishing silver and Sheffield Plate trade from his own workshops. The hub of his business was the manufacture of a vast range of buckles, toys and furniture fittings in brass, which he managed to produce at competitive prices to a consistently high quality.

In 1760, his business had outgrown its existing premises and he built a new factory at Soho on the outskirts of Birmingham. It was there, between the years 1768 and 1782, that he also produced ormolu.

Ormolu, adapted from the French word *or-moulu*, literally meaning ground gold, is used to describe decorative objects and mounts for furniture and porcelain in copper, brass and bronze which has been gilt by the process of fire or mercurial gilding. The word, which was introduced into England in the early 1760s, is usually only used to describe pieces dating from after the mid 17th century.

In order to gild by this method the gold is reduced to a powder and amalgated with mercury at a high temperature. The proportions are usually six parts of mercury and one of gold. On cooling, the gold amalgam is squeezed through a chamois leather in order to remove the superfluous mercury. This leaves a paste of about the consistency of butter which is roughly two parts mercury to one of gold.

The surfaces of the metal to be gilt are cleaned thoroughly with nitric acid and smeared with mercuric nitrate. The amalgam is then applied with a brush or gilding knife, and the object heated until the mercury has evaporated, leaving the gold bonded to the surface. Surfaces that need to be coloured further can be reheated or treated with various chemicals, and areas burnished or matted as desired. Boulton favoured the contrasting texture that this provided, and experimented with a wide variety of chemical compounds to provide his products with coloured finishes. He was extremely discreet about the recipes used which were never recorded and the knowledge of them has now been lost. Prudence about such matters on Boulton's part was wise for it was in this area that he was in particular competition with the French.

Because mercury vapour is toxic, mercurial poisoning among the work force was alarmingly high. The average life expectancy for a gilder in the 18th century could be as low as thirty years. For this reason, fire gilding is forbidden today except under carefully controlled conditions, and gilding is normally carried out by the process of electrolysis.

Boulton's designs for ormolu generally followed the fashion for the 'antique taste', the term by which the revival of the classical idiom in architecture and design was generally known. The excavations at Herculaneum, started in 1738, and at Pompeii, in 1755, did much to stimulate public interest in classical antiquity. The 'Grand Tour' of Italy by men who had the leisure and wealth to do so, and the numerous publications illustrating and describing the excavations, helped spread enthusiasm and knowledge for classical remains. Some of the more important publications were Piranesi's *Della Magnificenza ed Architettura de' Romani* (1761), *Recueil d' Antiquités* (1752–1767) by the Comte de Caylus, and Stuart and Revett's *Antiquities of Athens* (1762–1815). Moreover, English architects such as Robert Adam and William Chambers who travelled to Italy copied and drew freely

on classical ornament for their own designs and were in turn imitated by their colleagues back home. The publication of d'Harcanville's catalogue of the antiquities in the collection of Sir William Hamilton was intended to provide suitable source material for contemporary designers.

Boulton was personally acquainted with many of the leading English architects and designers who had visited Italy. He was in any case a cultivated man who read extensively and who was able successfully to incorporate classical motifs and principles into his own designs. Despite his ormolu venture ending in financial disaster, his products had quickly gained a European reputation and remain important contributions to the English decorative arts.

The work of Matthew Boulton and the other Birmingham brass manufacturers of the late 18th century covers an important period of transition for the brasswork industry. During his lifetime, and partly due to his efforts, it changed from one with craft traditions and practices to one which was dominated by mechanized methods of manufacture. Throughout the 19th century, the accelerating growth of the country's population and the rapid extension of the Empire expanded the market for brass goods enormously.

New developments in smelting procedures, described earlier, meant that brass could be produced very cheaply. This in itself created new markets, and these substantially altered manufacturers' priorities. In order to maintain their competitiveness, they had to produce on a large scale and with minimal costs.

The Patent Chimney Ornaments, manufactured by the firm of B. Day and Sons, Birmingham, exhibit some of the essential characteristics of the new industrial products. Made from machine stamped brass in about 1825 they were versatile, practical and fashionably decorated with Gothic ornament.

The Gothic mode was one of the styles which became well established early in the Victorian period. It was very successfully promoted by A. W. N. Pugin (1812–52) who was an architect, antiquary, designer and writer. He scorned such efforts as Day's ornaments and in 1838 entered into an association with John Hardman the younger of Birmingham. They styled themselves as medieval metalworkers and rapidly expanded the scope of their production, supplying not only brass furnishings for churches but also executing a great deal of work for the Houses of Parliament.

Hardmans were pre-eminently successful in providing well executed designs, in sympathy with the material used. One of their candelabra, designed by Pugin, was supplied to the House of Lords. A version of this, was purchased by the Victoria Albert Museum from the 1851 exhibition.

The illustrations in any of the Elkington catalogues of the

1870s give some indication of the type and range of products which were popular. The majority of items were cast; a method which was eminently suitable for large-scale production. Their table centrepieces, clock cases, inkstands and boxes were perennially popular. Elkingtons were principally silversmiths and were famous for the commercial development and exploitation of the electroplating process. The designs they offered in brass were not significantly different from those made from silver or in electroplate. Indeed many features were identical and lead one to suppose that in the many cases the same casting models were used irrespective of the material.

Towards the end of the 19th century various attempts were made to break Elkington's industrial monopoly in brass production. The Guild of Handicrafts which was part of the Arts and Crafts Movement inspired by William Morris attempted to revive traditional standards of craftsmanship in copper and brass. They enjoyed a limited success, but they did not have the financial and commercial advantage of the major manufacturers.

In contrast the work of Christopher Dresser and W. A. S. Benson had more immediate consequences. Dresser was trained as a designer and a botanist. His approach to design was tempered by his training in scientific analysis and his products were a radical combination of functionalism and simplicity. Benson, an architect by training, was a close associate of Morris and the remainder of the Arts and Crafts movement. His designs are consequently rather more stylized but he had one major premise in common with Dresser. Both fully accepted the implications of mechanical production and designed exclusively for it. In this, they paved the way for the influential movements of the twentieth century, such as the Wiener Werkstätte and the Bauhaus.

Art Nouveau, at the turn of the century, was a brief, self-conscious, attempt to create a new style in opposition to the eclecticism of the period. It was more popular on the Continent than in England where it was closely associated with the Arts and Crafts Movement.

The popular, and by far the dominant, trade in brasswork by now was altogether divorced from any aesthetic considerations. Improvements in the smelting of zinc, and the increase in copper supplies throughout the world, had made brass a cheap and easily workable material for the mass market. A fitting epitaph for this book is an illustration from the Pearson Page catalogue for 1927. The company was one of many started in the 19th century, supplying a vast range of household furnishings and trinkets at a price that was within reach of everyone. Totally devoid of any aesthetic merit or any appreciation of the material, this catalogue speaks eloquently of the decline of the brasswork industry.

Detail from the *Pearson Page catalogue*
Birmingham and London, 1927
E2059–1952

5¼ × 5 in.
KANGAROO.
Brass Book Ends No. 14674 32/-
Metallic Book Ends No. 14674 16/-
Brass Book Rests No. 15139 17/-
Brass Letter Racks No. 15255 21/-

PLATE 1
Cup
Copper, partly gilt
Hungarian, 17th century
The inscription round the rim reads 'Ich stame her von Eissen, doch eines wassers macht, hat mich zu kupffer beissen in Herrengrunden schact'.
H. 2″ Diam. 3″ (5 × 7.5 cms)
M796–1891

The inscription alludes to the method of obtaining copper in the Herrengrund area. The peculiar geological properties of the region provided readily accessible supplies of the mineral. Water, seeping through deposits of cupriferous ore, gained a high concentration of copper sulphate. Iron scraps were placed in hollows where the water collected and reacted with the copper sulphate to precipitate copper out of the solution. The copper either settled as a sludge or formed a crust over the surface of the iron which gave rise to the legend that the water had mysterious, if not magical, properties. It was further amplified by inscriptions, appearing on puzzle cups like the one illustrated, which read, 'Iron I was, copper I am . . .' or 'First iron, now copper, what miracles are wrought in Herrengrund'. Such cups were often adorned with small maquettes representing miners at work and were popular throughout Europe during the 16th and 17th centuries. They were showpieces and the persistence of the legend inscribed on the rims demonstrates the public ignorance of metallurgy. By the 18th century, when popular knowledge of chemistry had increased, the attraction for this type of object inevitably declined.

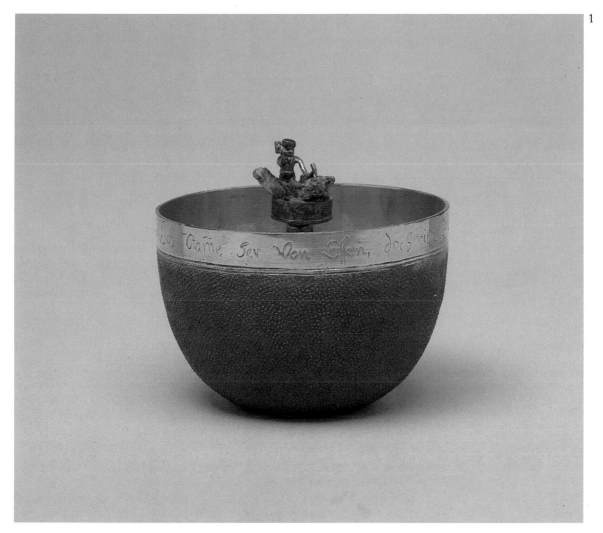

1

PLATE 2
Skillet
Brass
Flemish (?), 16th or 17th century.
H. (including handle) 6¼″ Diam. of lip 5½″ (15.5
× 13.75 cms)
M158–1941

Cauldron
Brass with iron handle
Flemish, 14th century
H. 7⅛″ W. 8″ (17.8 × 20 cms)
M29–1965

Skillet
Brass
English, 18th century
Cast with P. Warner on the handle
H. 4″ Diam. 4.7″ (10 × 11.75 cms)
M411–1917

Cauldrons were among the most essential items of
household equipment. Brass founders began to
manufacture these vessels in the 13th century,
adopting a design that was very similar to earlier
versions in glazed earthenware or stoneware. The
earliest examples were spherical in shape,
supported on three or four legs, with an iron
handle attached to two brackets on either side.
These could be either suspended over the fire, or
placed next to it on the hearth.

This design was eminently functional and very
popular throughout Northern Europe for at least
two centuries after its introduction in brass.
Usually very little embellishment was added and it
can therefore be difficult to date specimens with
any accuracy. The earliest examples tended to have
high legs, ending in claw feet; a feature which was
probably borrowed from the aquamanile, an ewer
cast in the shape of various animals, which was
popular at the time when the first cauldrons were
being made. It would seem reasonable on this basis
to assign the cauldron in the centre of the
illustration to the 14th century.

Gradually variations were introduced. As early
as the 14th century the spherical shape was
sometimes abandoned in favour of a wider and
flatter body, which was a more economical and
practical design, if less aesthetically pleasing. By
the 16th century some workshops had abandoned
the iron handle altogether and instead attached a
single protruding handle, just on or below the rim,
supported by a bracket at the junction of the
handle and the vessel itself.

On English versions, the handle would normally
be flat and sometimes inscribed with the maker's
name, as in the example on the right, or with
some suitable homily such as 'pitty the pore'.

During the 16th and 17th centuries new shapes
began to be used for the vessels themselves; some
had flat sides with an aperture wider than the base
which itself was flattened so that a greater surface
area could be exposed to the heat.

The three supporting feet remained a feature
until the end of the 18th century, becoming smaller
and smaller until eventually they became mere
stumps protruding from the base. Nonetheless the
traditional sperical shape continued to be popular,
as the example on the left illustrates. Although this
skillet was initially assigned to the 13th century,
the elaborate decoration, the squat legs and the cast
side handle all suggest a later date. It is more
probable that this is a 17th century object made in
Flanders.

PLATE 3
A selection of three brass dishes
Brass
Flemish or German, 15th century
Diam. 10⅜″ H. 2⅜″ (26.3 × 6 cms)
M355–1924, M353–1924, M124–1937

The themes incorporated on these three dishes are
typical of the period. These are, from left to right,
'The Two Thieves coming out of the land of
Canaan', 'The Annunciation' with the unicorn
as a symbol of Mary's virginity and the four little
dogs of her fidelity and 'The Paschal Lamb'. Other
typical biblical themes included 'Adam and Eve',
'Samson and the Lion' and 'St Matthew between
two angels' but the inspiration for these embossed
designs was not exclusively religious: there is
another example of a contemporary dish in the
V&A's collection which bears a portrait of Cicero
so classical themes were evidently also popular.

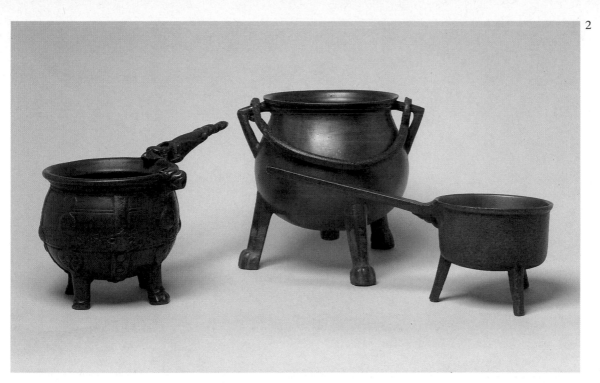

2

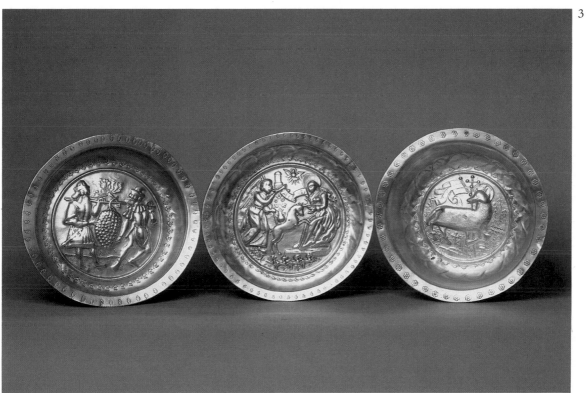

3

19

4

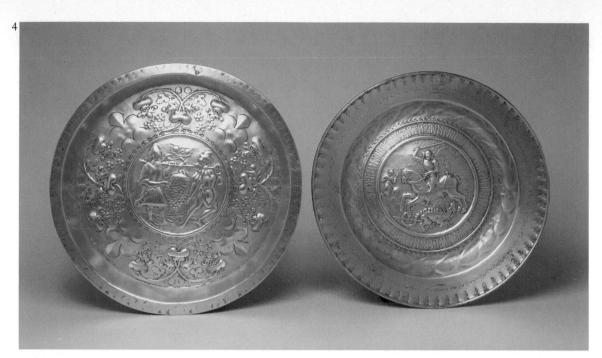

5

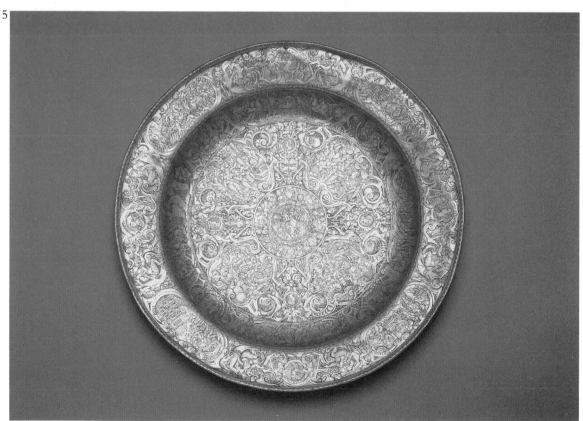

PLATE 4
Dish
Brass
South German, probably late 15th century
Stamped with the two thieves coming out of
Caanan.
Diam. 16″ (40.5 cms)
M349–1924

Dish
Brass
South German, probably early 16th century
Stamped with St George and the Dragon, and on
the rim the owner's coat of arms.
Diam. 15⅛″ (38 cms)
M335–1924

Dishes with this deep rim appear in a number of
late 15th century German paintings. These larger
dishes are indicators of the later developments in
the evolution of the brass dish. The dishes become
greater in diameter, at first retaining the deep rim,
and then progressively becoming shallower. These
two examples illustrate the transition between the
small 15th century type with its essentially pictorial
decoration and the large, flatter version, popular in
the 16th century which incorporated abstract
motifs in a tightly organized design.

PLATE 5
Dish
Brass
Italian, Venetian dated 1562
Engraved with the name of the artist and the date
Signed HORACIO. FORTEZZA. FECE. IN. SEBENICO.
DEL. LXII
Diam. 18″ (45 cms)
572–1899

This dish is extensively engraved with scenes from
Roman history and portraits of various Roman
emperors and authors. Among the subjects
represented are: 'The Rape of the Sabine Woman',
'Scipio at the Burning of the Fleet at Carthage' and
'Coriolanus receiving his mother, wife and child
outside the gates of Rome'. These scenes are
interspersed with medallions containing portraits of
such figures as Plutarch, Livy, Claudius and
Augustus. The engraved armorial at the centre
bears the arms of the Delfini family.

This dish is most unusual in that it is signed and
dated: an indication not only of the craftsman's
self-confidence but also of the importance attached
to such commissions in Venice.

PLATE 6
Bowl and cover
Brass, engraved and inlaid with silver
Venetian Saracenic, early 16th century
On the lid is the signature of the maker, Mahmud
al Kurdi
H. 3¼″ Diam. 6″ (8 × 15.3 cms)
2290–1855

During the 15th and 16th centuries trading and
political contacts grew between Europe and the
Middle East. Venice, because of its political
influence and geographical position, was the
immediate beneficiary. By the late 15th century it
had its own Moslem community which decorated
its brasswork with engraved and inlaid patterns of
interlaced ornament, wholly Saracenic in origin.
There are some splendid examples of this
damascened brasswork in the Museum, some of
which such as this bowl and cover are signed in
Arabic by their makers.

By the 1530s Italian craftsmen began to study
this distinctive style of ornament and incorporate
elements of it into their own designs. The Italian
engraved dish (PLATE 5) is decorated with
interlaced strapwork which is derived from
Saracenic and not classical ornament.

PLATE 7
Mortar
Brass
German, probably Nuremberg, second half of the
15th century
H. 7″ W. 6.1″ (17.8 × 15.5 cms)
M73–1914

Mortar with pestle
Brass
Dutch, dated 1540
Cast with an inscription which reads, 'Ottocar
Richter had me made; Segeeuimus Hatiseren made
me.'
H. 7½″ W. 8½″ (19 × 21.5 cms)
2176 and a – 1855

Mortar
Brass
German, Nuremberg, first half of the 15th century
H. 8½″ W. 8″ (21.5 × 20.4 cms)
1166–1864

Mortar
Brass
Possibly Flemish, about 1500
Cast with an inscription round the rim in Latin
which reads, 'Whoever wishes to be cured quickly
from bitter illness must oppose it from the first to
avoid worse things.'
Stamped on the edge of the foot with a

founder's mark which remains unidentified.
H. 5¾″ (14.6 cms)
M7–1938

Mortars have been used by apothecaries for the
preparation of medical products for centuries and
remain the symbol of the pharmaceutical trade
today. They were introduced to Europe from the
Near East in the 11th century where medical
science was well in advance of contemporary
European practice. Mortars were also one of the
earliest domestic items produced in brass, where
they were used for grinding spices.

By the 15th century mortars were decorated for
the first time, with delicate vertical ribs running
lengthwise up the side of the vessel. At the base,
the ribs are transformed into feet and raised to
stand away from the vessel. Occasionally motifs
may be moulded in relief between the vertical ribs
on the side of the vessel. On very elaborate and
valuable examples such as the third from the left,
the ribs arch at the top to form an ornamental
canopy.

The characteristic shape during the 15th century
was that of a tall vessel, with the aperture of
approximately the same diameter as the base.
Handles at the side of the vessel could be square or
rounded.

During the 16th century, developments in the
design and production of mortars in Italy
influenced the rest of Europe. The basic shape was
changed so that the diameter of the aperture was
half as large again as the internal diameter of the
base and the height was roughly equivalent to the
larger diameter at the top. The vertical ribbing
disappeared altogether and was replaced by
decorative horizontal freizes in relief. The Italians
frequently employed figurative imagery as well as
ornamental motifs. The northern European
craftsmen more often restricted themselves to a
purely ornamental style of decoration. Inscriptions
cast into the sides of the vessel and bearing either
the owner's or the maker's name (and sometimes
both) became popular. On more elaborate
examples (see the mortar on the right), the
inscriptions were more extensive and were related
to the object's intended function.

The fashion for highly decorated mortars
continued until the 17th century. By the 18th
century, mortars were once again plain, functional
objects, but their popularity was in any case on the
decline. Developments in both the spice and
pharmaceutical trades meant that ingredients were
increasingly supplied in powdered form and by
1800 such vessels were no longer generally
necessary.

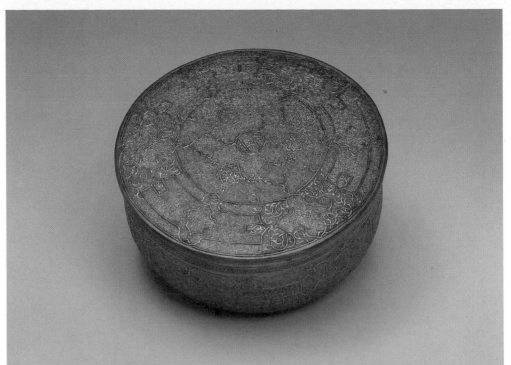

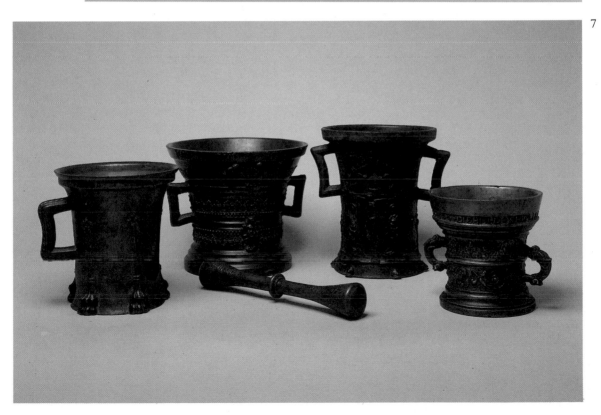

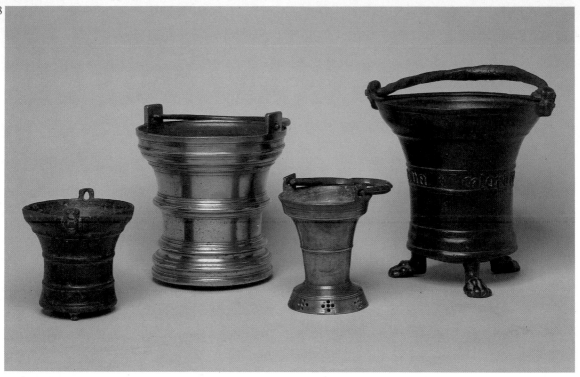

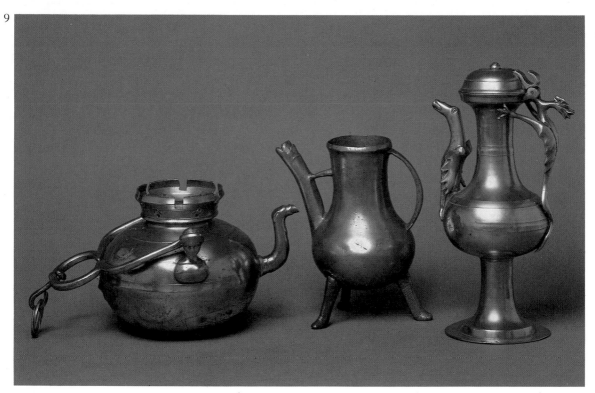

PLATE 8
Holy water bucket
Brass
Flemish, 15th century
H. 4⅜″ W. 5″ (11 × 12.2 cms)
M195–1926

Holy water bucket
Brass
Flemish, 16th century
H. 6½″ W. 6½″ (16.5 × 16.5 cms)
470–1911

Holy water bucket
Brass
Flemish, 15th century
Dimensions H. 4⅜″ W. 3⅞″ (11 × 9.7 cms)
602–1864

Holy water bucket
Brass
North German, second half of the 14th century
Cast with the inscription 'AVE REGINA CELORUM'
(Hail Queen of the Heavens)
H. 8⅛″ W. 8¼″ (20.5 × 21 cms)
M5–1953

Buckets were first made in brass because a grander version than their wooden prototype was required for liturgical ceremonies. At first there were many basic similarities between the two. Those in brass copied the tapering profile (of those in wood) and were decorated with horizontal lines encircling the rim, centre and base, reminiscent of the metal hoops holding the staves together. Gradually craftsmen began to evolve forms peculiar to brass. Buckets were cast with a circular stepped foot which could be decorated with a pattern of perforations. In Northern Germany buckets were occasionally mounted on three short legs, sometimes no more than stumps, which created stylistic similarities with contemporary cauldrons and three legged jugs (PLATES 2 and 3). Inscriptions around the side of the vessel were sometimes incorporated on the more elaborate examples. Handles were often a single iron hoop but again there were variations. On some examples, the double-hooped handle in cast brass more commonly associated with lavabos was used.

The second from left and latest example bears little relation to its standard wooden counterpart. The elegantly swelling sides and the series of raised ridges encircling the body catching and reflecting the light fully exploit the decorative value of the metal.

Buckets were also produced for secular use but the stylistic variations were undoubtedly prompted by ecclesiastical commissions. Throughout the Middle Ages, church art was more susceptible to changes of fashion than the highly conservative domestic market.

PLATE 9
Hanging laver
Brass (one spout broken and at one time restored in lead)
Flemish, 15th century
H. 6¾″ W. 12″ (17.2 × 30.5 cms)

Ewer
Brass
Flemish, 14th century
Found in a disused well at Ashby-de-la-Zouch Castle in 1937
The well in which this and a pewter cruet were found had probably been disused since the building of an adjoining tower in 1476 (see the *Antiquaries Journal*, Vol XVIII, 1938, p. 178.)
H. 9⅛″ Diam. 5⅛″ (23.2 × 13.0 cms)
M25–1939

Ewer
Brass
Flemish, 15th century
H. 12¼″ Diam. 4¾″ (31 × 12 cms)
539–1869

The object on the left of the illustration is an early example of a lavabo which in many households gradually displaced ewers as a means of dispensing water for washing one's hands. Occasionally they were made with a single spout. It was more common however for there to be two, placed equidistant between the two supports for the handle.

The basic shape of the body was usually that of a flattened sphere. The rim, the spouts and the junctions of the loop handle with the body were opportunities for the craftsman to demonstrate his artistic skills. It is not unusual to find a human bust concealing the join. The spout, shaped like the head and open jaws of some fabulous creature, was not restricted to lavabos but incorporated in the design of ewers as well. The source of this motif remains obscure but it remained popular for a long time and was indeed still being used to embellish teapots and coffee pots until the late 18th century.

Brass jugs on three supporting legs are rare; this design did not undergo any systematic development and was relatively short-lived. All surviving examples date from the late 13th or 14th centuries and were made in Flanders. Although it is reasonably certain that such vessels were not used to heat or serve water since such functions were served by other vessels, it is possible that they were used to dispense mulled wine since this was a popular drink at the time.

Brass jugs supported on a pedestal foot were a later development and were frequently used in conjunction with brass dishes, as an alternative to the lavabo.

PLATE 10
A group of four sets of weights
Brass, cast, turned and chased
German, Nuremberg 16th and 17th centuries

(From left to right):
a) Maker's mark of Leo Abhend (c 1707)
H. 3⅜″ Diam. 4″ (8.6 × 10.2 cms)
280–1900

b) No marks
Early 17th century
These weights were once officially used in Spain.
They are stamped with a shield of arms for
Tarragona and the tally master 'IED
ALVARADO'
Maximum weight – 25 lbs
H. 9⅝″ W. 7⅛″ (24.5 × 18 cms)
M279–1900

c) Maker's mark attributed to Hans Kurtz
Middle of the 16th century
Maximum weight 32 lbs
H. 6½″ W. 9″ (16.5 × 23 cms)
1205–1864

d) Maker's mark of Sebastian Kunzel, recorded as
working in 1676 and 1677
Maximum weight – 64 lbs
H. 15″ Diam. 10½″ (38 × 26.7 cms)
559–1872

The weight makers in Nuremberg were second
only to the basin beaters in importance. By the
15th century they sold their products throughout
central and southern Europe and continued to
dominate the market until the 18th century.

The Nuremberg makers were particularly
famous for their 'nests' of weights. The 'nest' was
a series of cast buckets, fitting precisely inside each
other. The outermost bucket was often richly
decorated with a series of freizes of either engraved
interlaced ornament or rows of embossed
decoration. The remaining inner ones were left
absolutely plain. The sockets on the lid for the
loop handle were often modelled as human busts.
The handle itself, and the lock fixing the lid to the
body, were elaborately cast and chased in the
forms of some mystical or fabulous creature. These
motifs were common to many workshops and
were occasionally borrowed for use on other items.

The production of such weights was rigidly
controlled. Each bucket within a series had to
correspond to a statutory weight and had to be
individually tested. Each series was required by the
town council to be stamped with the maker's
mark, the town mark (which was the letter 'N'),
and finally the inspector's mark. The only
exceptions to this were sets made for export which
did not have to be marked.

PLATE 11
Supporting ring for a stove pipe
Brass
German, dated 1595
The inscription, cast round the edge reads:
'HAT MICH VERHERT DEM ERBAN UND FURNEHMEN
PAVIO DILHERN'
(I was presented by the honourable and
distinguished David).
'ICH BIN DURCS FEUER GEFLOSSEN MAIER HAT MICH
GOSSEN'
(I have flowed through the fire; Christoff Maier
cast me).
H. 2″ Diam. 9¾″ (5 × 24.7 cms)
2294–1855
Stand for a stew pan
Brass
Swiss, 15th century
Diam. 8¾″ (22.3 cms)
1596–1855

Casting was one of the brass founders' basic skills.
The supporting ring is evidently a testpiece for a
guild examination and the fact that a piece of cast
work was chosen for such an exercise indicates that
the trade considered casting skills as supremely
important.

The examinee would be allotted a workshop and
would be required to produce a sample within a
specified time. This examination was supervised by
the guild and if the candidate's work was
considered satisfactory, he would be presented
(before its assembled members) by his sponsor as a
new master.

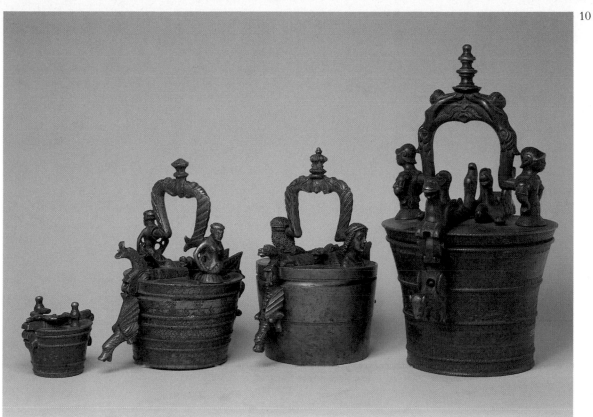

10

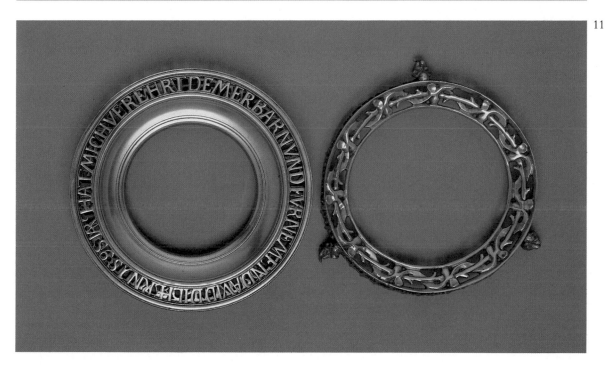

11

27

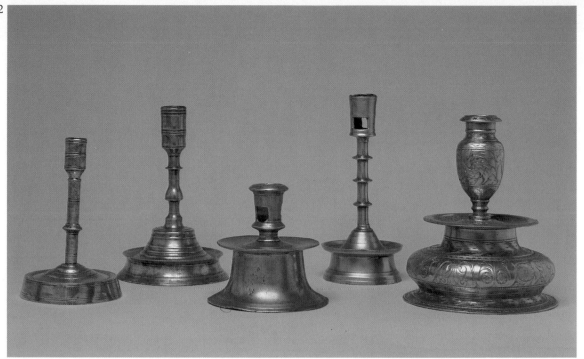

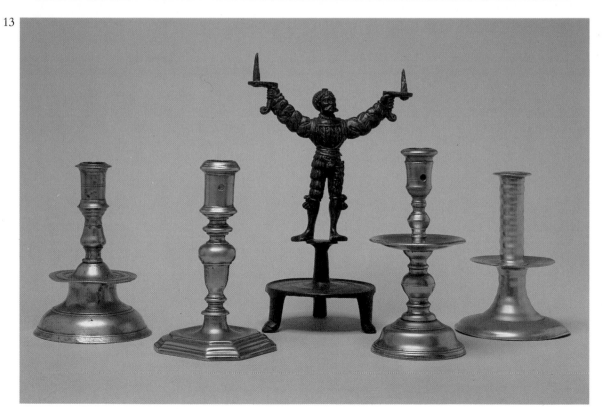

PLATE 12
Candlestick
Brass
Flemish, early 16th century
H. 6⅛″ W. 3⅞″ (15.5 × 9.8 cms)
M18–1964

Candlestick
Brass
English, early 16th century
H. 6⅝″ Diam. 4⅛″ (16.8 × 10.5 cms)
M56–1922

Candlestick
Brass
Flemish or German, early 16th century
Maker's mark or a merchant's mark in a shield.
H. 4¾″ W. 4⅝″ (12 × 11.7 cms)
M19–1964

Candlestick
Brass
Flemish, late 15th or early 16th century
H. 7¾″ Diam. 3¼″ (19.5 × 8.2 cm)
M227–1912

Candlestick
Brass
German (Nuremberg), late 16th century.
Maker's mark S.G. separated by a slipped trefoil
probably for Sebald Gesheid of Nuremberg,
recorded 1567 and 1597
H. 7¼″ Diam. 6″ (18.5 × 15.3 cms)
4857–1856

PLATE 13
Candlestick
Brass
Flemish, early 17th century
H. 6¼″ Diam. 4½″ (15.9 × 11.5 cms)
M306–1912

Candlestick
Brass
Dutch, c 1690
H. 6¾″ W. 3¾″ (17.2 × 9.5 cms)
M1047–1926

Candlestick
Brass
Germany, early 16th century
The stem is formed as a figure of a Landskrecht.
The sword and hat are missing. Neither pricket is
original
H. 10″ W. 6½″ (25.5 × 16.5 cms)
M2–1945

Candlestick
Brass
Dutch, second half of the 17th century
H. 7⅛″ W. 3½″ (18.2 × 9 cms)
673–1904

Candlestick
Brass
English, mid 17th century
H. 6″ W. 4⅜″ (15.3 × 11 cms)
389–1906

From the 14th until the 17th centuries, brass
candlesticks appeared in all but the most
prosperous houses, and were made in forms
peculiar to the material.

Socketed candlesticks made their appearance in
the late 13th century and thereafter became
relatively common, replacing the earlier pricket
form, at least for domestic use. The earliest sockets
were polygonal in cross-section. By the 15th
century they were round. At first, two vertical
apertures opposite each other were cut into the
sides of each socket, in order to facilitate the
extraction of the burnt-out stub. As the production
of cheap tallow candles became more sophisticated
the size of these apertures became correspondingly
smaller. Again, by the 15th century, these
apertures tended to be horizontally cut. By the
second half of the 16th century the apertures were
small circular holes, until finally in the 18th
century they disappeared altogether.

The form of stem and the base of the late
medieval candlestick is the result of a complicated
interplay between two typological currents. The
first type naturally evolved from the simple
European pricket candlestick, where the shaft is
supported on three legs. The second type

originated in the Near East. As early as the 13th century the characteristic Near Eastern brass candlestick had a high cylindrical or slightly conical base surmounted by a flat circular wax pan and a short circular stem. These were introduced into Europe by the Moslem community in Venice from the 14th century. They account for the high bell-shaped bases which appear on many Northern European and Saracenic candlesticks during this period. Broadly speaking the development of the base can be attributed to foreign influence, while the stem is largely European in origin. But one must be careful about taking this distinction too literally. The gradual elongation of the stem with an increasingly complicated range of knops and balusters initially appeared on Saracenic examples.

During the 15th and 16th centuries, an interesting variation was the replacement of the conventional shaft with a model of a human figure in contemporary dress; the outstretched arms supporting either a pricket or a socket with a drip tray immediately underneath (*centre*).

By the middle of the 17th century, the drip tray was becoming increasingly distant from the foot. The unmistakeable trumpet-shaped candlestick (*right*), cast in two sections with its drip pan appearing half way up the column, is an example of this. The body is hollow cast and thus the corrugations serve to strengthen the shaft. The nozzles at the top were usually detachable and were necessary to prevent the candle falling into the shaft as the wax melted. The trumpet-shaped stick is thought to be English while the 'collar' candlestick (*second from right*) cast in solid brass in three and sometimes four separate sections was immensely popular in the Low Countries until the early 18th century. It was a supremely practical design being sufficiently heavy to sit securely on rough oak tables and yet eminently suitable to be carried round the house as required. The high drip pan protected the hand from hot melted wax.

PLATE 14
Warming pan
Brass
Dutch, dated 1602
In the centre Venus and Cupid
Inscribed around the edge:
'DEES * PAN * IS * REQVAEM * VOOR * VROVWEN * DIE * GEEREN * IN * EEN * WERN * BEDT * GHAEN * EN * NIMANT * EN HEBBEN * OM * HEN * TE * VERWERMEN * SOD * MOETEN * SI * HAER * BEDT * VIREN * MET * DE * PAN * ALS * SI * NIET * EN * HEBBEN * EENEN * MAN * DIE * HEN * DE * VOETEN * VERWERMEN * KAN * ANNO * 1602'
(This pan is suited for women who like to sleep in a warm bed and who have nobody to warm them, so that they have to fire their bed by means of a pan if they haven't got a man who can warm their feet for them. ANNO 1602)
Diam. 13½" (33.5 cms)
4214–1855

This is an exceptionally fine example of pierced and engraved work. Its quality, and erotic theme, suggests that it may have been intended as a marriage gift. By the middle of the 17th century warming pans were common household objects. They were not, as it is sometimes thought, left in the bed, but were inserted, and stroked swiftly between the sheets by a servant, just before the master or mistress retired. Some dexterity was needed to avoid scorching the linen.

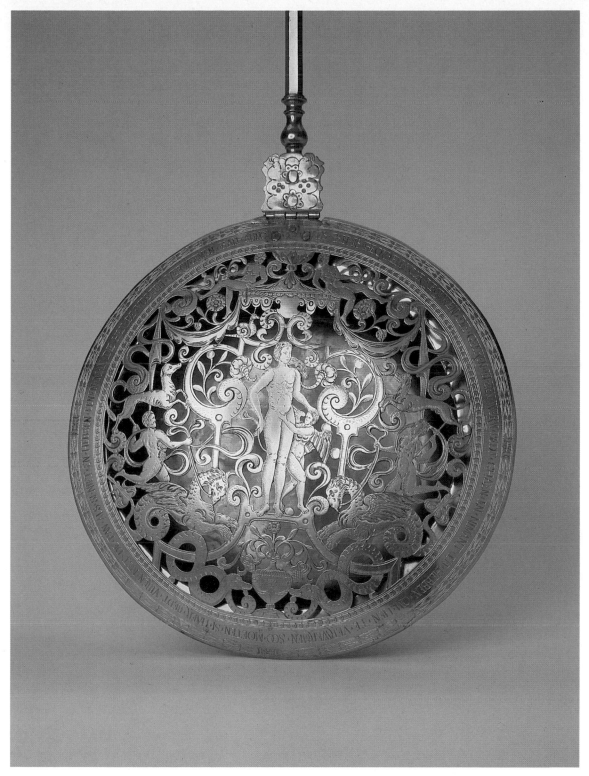

15

16

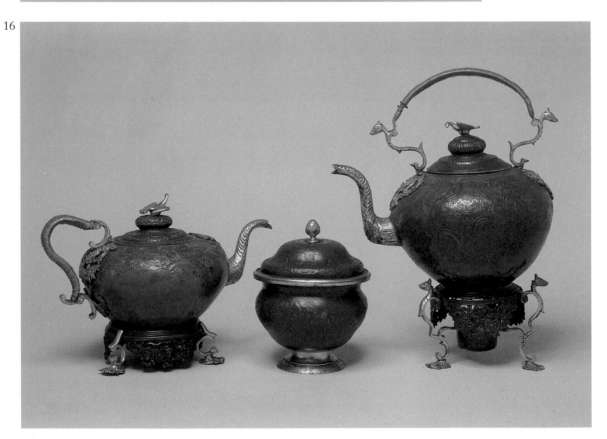

PLATE 15
Curfew
Brass
Dutch, 17th century
H. 16″ W. 24″ (40.5 × 61 cms)
94–1891

During the medieval period and up until the early
19th century it was the custom, if at all possible,
never to let the fire die. Obviously to have a fire
burning all night was both extravagant and
dangerous and so to overcome this, a cover called
a curfew (from the French *couvrefeu*), was placed
over the embers each evening when the household
retired to bed. It was usually made in sheet brass
or copper, in the form illustrated. It was placed
over the embers, and pushed to the back of the
fireplace, thus restricting almost all ventilation. In
the morning it would be removed, the embers
raked and fresh fuel added.

 Although they must have once been
comparatively common, surviving examples are
rare.

PLATE 16
Tea kettle and teapot with stands
Copper, chased and embossed with gilt details
Dutch (?), mid-18th century
Tea kettle H. 13¼″ L. 10⅞″ (33.6 × 27.7 cms)
Tea pot H. 7½″ L. 11¾″ (19 × 30 cms)
M 144 and a–1919

Slop bowl
Copper, chased and embossed with chinoiserie
rocaille and with gilt details
Dutch (?), mid 18th century
H. 6⅝″ Diam. 5¼″ (16.9 × 13.3 cms)
M144c–1919

These pieces form part of a tea service and
highlight some of the problems faced by the
historian when trying to provide accurate
information about copper and brass objects. There
is no hallmarking system, as in the case of silver,
which can provide the historian with a precise date
and origin of manufacture. The chinoiserie
elements bordered with scroll-like decoration on
the pieces illustrated are clearly in the rococo taste
and one can reasonably date these pieces to the
18th century. Their origin, however, remains
obscure. When these pieces were first acquired by
the V&A they were thought to be English but no
firm evidence exists to support this. Similar pieces
do appear in Dutch paintings of the period and
recently they have tentatively reattributed as
Dutch.

PLATE 17
Tobacco box (Top Left)
Dutch, dated 1676
Engraved on the lid with the arms of William of
Nassau, later William III of England and on the
side with an inscription which translates, 'Even if
the branch breaks, and the rushes bow down,
Orange is still not dismayed'. The name of the
owner, 'Tan van Otterspoort', is also inscribed.
H. 1¼" Diam. 4" (3.2 × 10 cms)

Tobacco box (Bottom Left)
Brass
English, dated July 4, 1746
Engraved with the name of the owner, William
Lister.
H. 1½" L. 5" (3.8 × 12.2 cms)
M1029–1926

Snuff box (Centre)
Stamped Brass
English, c.1805
Signed 'M & P fecit'
The top of the box bears a portrait of Lord
Nelson, and on the reverse the following legend is
stamped, 'CONQUEROR AT ABOUKIR 1 AUG 1798
COPENHAGEN 2 APRIL 1801 TRAFALGAR 21 OCT
1805 WHERE HE GLORIOUSLY FELL.'
H. 1" D. 2⅞" (2.6 × 7.5 cms)
M221–1939

Writing box (Top Right)
Gilt Brass
German, second quarter of the 16th century
Engraved with two scenes symbolizing human
chaos and corruptibility. On the lid a wildman
with the inscription in German, 'When evil lust
leads us astray, man becomes an animal', and on
the reverse the traditional image of human chaos, a
fool breaking up household implements, with the
inscription in Dutch, 'St Nobody is my name'.
L. 4⅞" W. 2" (12.4 × 5.1 cms)
M 2823–1931

Writing box (Bottom Right)
Brass
German, dated 1544
L. 7¼" W. 1⅞" (18.5 × 4.8 cms)
M97–1953

Portable writing boxes fulfill an obvious function.
They were designed so that they could
conveniently slip into a pocket or pouch and
contain their contents without undue disarray. In
the examples illustrated a hinged lid opens to
reveal a small cavity in one corner to hold ink and
a lateral division running the length of the box to
separate the quills.

The shape of writing boxes was prescribed by
their function while those intended to carry
tobacco or snuff could be designed with more
freedom. Tobacco is said to have been first
introduced into Europe in 1560 by Francesco
Hernanday, a Spanish physician, who obtained it
in Mexico. Smoking was popular by the mid-17th
century in England and Holland, though the taking
of snuff was always considered more socially
acceptable. It became immensely popular in the
reign of Queen Anne, after a Spanish consignment
was commandeered at Vigo Bay in 1703.

Both activities were essentially masculine and so
such objects, if decorated at all, usually
incorporated subjects such as political and military
victories or erotic themes.

These boxes were made from sheet brass and,
or, copper for lightness and ease of manufacture.
The one exception amongst those illustrated is the
top right where the body of the box is cast but this
is unusual. Decoration could therefore be applied
by engraving or stamping.

PLATE 18
Tobacco box
Brass
Dutch, early 18th century
This box is extensively engraved with scenes
depicting love and tyranny. On the exterior surface
of the lid the subject is Aeneas rescuing Anchises
from burning Troy; on the inside a scene of
adultery and an inscription in Dutch which
translates, 'How can a young woman bully an old
man? Another makes the baby and I like a mother
rock the cradle'. The box has a secret lid engraved
on both sides: a domestic scene and the inscription
'I have an old husband who gives me no pleasure,
but Venus manages the business so that I have no
reason to complain' on one side and on the other a
woman hitting a man with her chateleine (an
ornamental appendage worn at the waist for
attaching useful objects), and the inscription 'O
miserable marriage, would that you had never
taken place'.

The base also has a false bottom, and the scenes
are a happy family, with the inscription, 'One
finds nothing so sweet in fidelity as love between
man and wife', and a warrior pursuing a woman
with children, with the inscription, 'Where man
despises true love, there is a land that stands in
evil'.

The underside is engraved with Alexander
visiting Diogenes.
H. 1¼" Diam. 4¼" (3.2 × 10.8 cm)
M175–1939

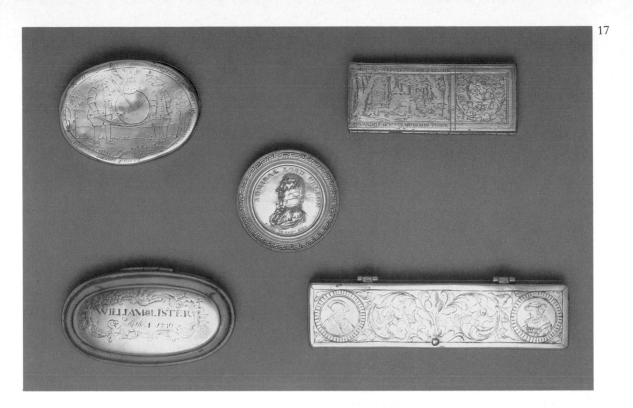

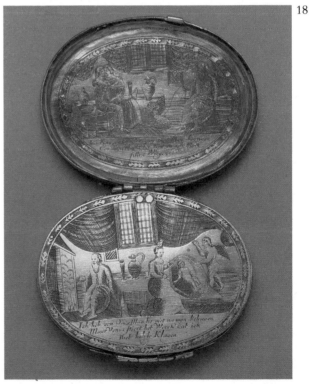

19

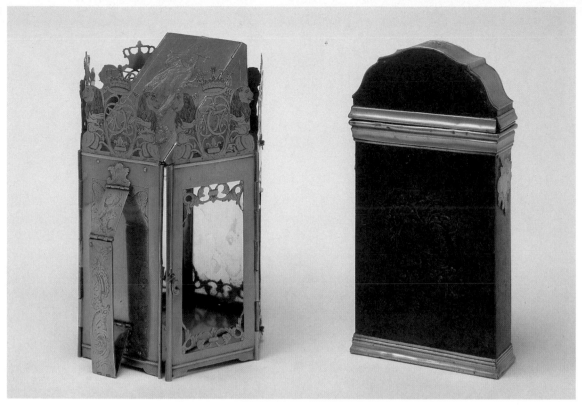

20

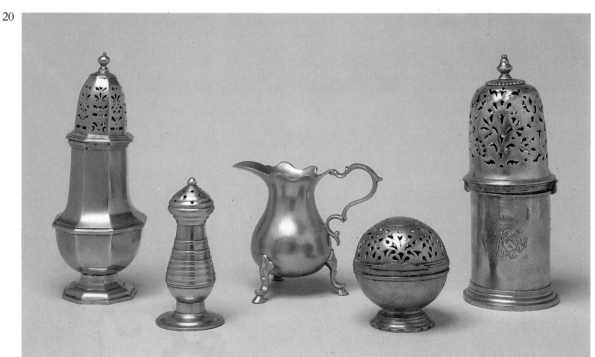

PLATE 19
Hand lantern and case
Sheet Brass and mica
Danish, late 18th century
Bearing the crowned monogram of Christian VII
(1749–1808)
H. 9⅞″ Diam. 6¾″ (25 × 17.2 cms)
537 a–1869

Sheet brass was eminently suitable for lantern
construction. It combined strength with lightness
and the interior surfaces, if brightly polished, could
reflect and intensify the light source.

Metal hanging or wall lanterns were not often
used until the late 18th century. Hand lanterns
were traditionally the most popular type and their
usefulness depended on their portability. By the
late 18th century, folding versions began to appear.
The example illustrated, which can be collapsed
and packed flat in the brass and iron case, is an
exceptionally fine specimen. The cover is
supported by a figure of Hope in openwork and is
engraved with a figure of Patience.

PLATE 20
Castor (one of a pair)
Brass
English, first half of the 18th century
H. 9⅛″ W. 3⅛″ (23.2 × 8 cms)
M655–1926

Castor
Brass
English, 18th century
H. 4½″ W. 2⅛″ (11.5 × 5.5 cms)
M254–1925

Cream jug
Brass, once silvered
English, mid-18th century
Stamped with the master's mark I★B and two lion
passant marks and another all imitating silver hall-
marks
H. 4¼″ W. 3½″ (10.9 × 9 cms)
M1050–1926

Soap container
Brass, with traces of silvering
French, mid-18th century
H. 3¼″ Diam. 3″ (8.3 × 7.6 cms)
M141–1939

Castor
Brass, with traces of silvering
Engraved with the arms of Alliand and another
accolade beneath a coronet.
French, late 17th or early 18th century
H. 8¼″ Diam. 3⅛″ (21 × 8 cms)
M956–1926

The English examples were probably all made in
Birmingham. They are certainly typical of the
tableware which was produced in considerable
quantity by the Birmingham manufacturers. On
close inspection, all pieces, with the exception of
the English castor (second from the left), bear
traces of silvering. Cast brass with a silvered
surface was a relatively common silver substitute
until the Sheffield Plate industry was established in
the mid-18th century. The discovery by Thomas
Boulsover in 1743 that copper and silver fused
under heat provided a much cheaper alternative.

PLATE 21
Salver
Silvered brass
English, 18th century
Engraved with the arms of Wentworth, Earl of
Strafford
H. 3½″ Diam. 11″ (9 × 28 cms)

Many brass objects belonging to the 17th and 18th
centuries were originally silvered. With almost all
of them the silver surface has been removed by
excessive polishing over the years. This salver is
unusual in that its silver surface has remained
virtually intact, except for slight traces of wear
around the base of the foot.

The silver coating was applied to the brass
surface by a process which was identical to fire-
gilding, except that powdered silver was
amalgamated with the mercury and not ground
gold.

Silvered brass was not always destined for
private ownership. It has been suggested that large
retail silversmiths initially produced their designs in
brass, then had them silvered and kept them as
stock samples for prospective customers. If the
client liked what he saw, he could then
commission a version in sterling silver. The
silversmith by this means avoided speculatively
investing in bullion and tying up his capital in
excise payments. The similarity in design of many
silvered brass objects with contemporary silver
examples would lend support to this theory.

PLATE 22
A selection of furniture mounts and casting models
Brass and boxwood
English, Birmingham, late 18th and early 19th
centuries
Lent by Messrs Cope and Timmins Ltd

Decorative brass fittings for furniture were
amongst the staple products of the Birmingham
and London brass founders during the 18th and
19th centuries. A glance through the printed
pattern books of metalwork in the V&A will
indicate the enormous range of decorative furniture
fittings that were available. Many of the same
patterns recur. There was no registered right to
any design in England during the 18th century,
unlike in Paris where metalworkers enjoyed the
protection of their guilds and, after 1766, were able
to protect their patterns by law. In England,
however, manufacturers borrowed freely from
each other. Popular patterns were supplied by a
large number of manufacturers and persisted for
many years.

The firm of Cope and Timmins was established
about 1760 and is still in business today producing
brass fittings. The earliest example in the
illustration is the wooden casting model for an
escutcheon which dates from c1780 and
corresponds to a plate in a catalogue headed,
'Escutcheon for a desk fall'. The wooden model
for a caster, in the centre of the photograph, dates
from the early 19th century. The two pieces of
scroll beading which border the right-hand side
and the bottom of the photograph are two versions
of the same design. One is fully finished while the
other is shown straight from the casting mould.

The plate at the top of the picture is a piece of
stamped brass and bears the firm's mark, COPES,
contained within a lozenge.

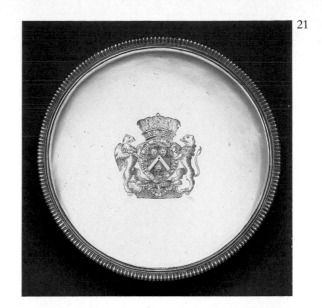

21

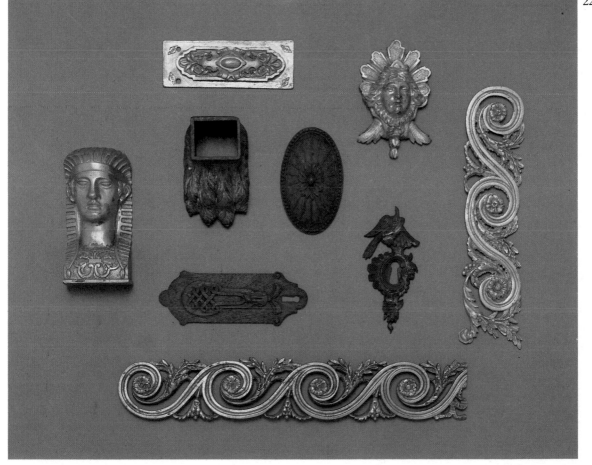

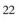

22

23

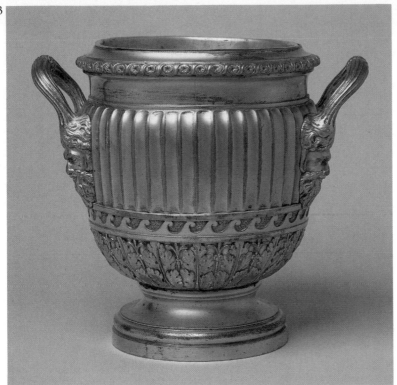

24

PLATE 23
Ice pail
Firegilt bronze with a tinned liner
English, Birmingham (Soho workshops) c1775
Attributed to Matthew Boulton
H. 8⅛″ W. 9″ (20.7 × 23 cms)
M295 and a–1976

The production of ormolu at Soho was confined to a short period between 1768 and 1782 and ice pails were amongst the first items that were suggested to Boulton as possible manufactures. The earliest was ordered by the Duchess of Ancaster in 1773 and production continued until at least 1778. In that year mounting stock, because of a disappointing public response, prompted Boulton to hold a sale of ormolu at Christies. Lot 44 was catalogued as a 'pint ice pail in ormolu, richly gilt, chased and lined with silver', and was reserved at ten guineas. The following lot was a similar pail for a quart bottle reserved at thirteen guineas.

The sale at least secured some much needed publicity for Boulton but financially it was not a success. Both lots mentioned above, for example, failed to sell and are probably those listed in the inventory of Boulton's stock taken in 1782.

PLATE 24
Candlestick
Brass
English, mid-18th century
H. 7⅝″ (19.4 cms)
M398–1917

Candlestick
Brass, (with an iron raiser rod in the stem)
English, late 18th century
H. 8⅞″ (22.6 cms)
M400–1917

Candlestick
Brass
English, c1710
Stamped with the makers mark I ★ B
H. 7¼″ W. 3⅞″ (18.5 × 10 cms)
M1101–1926

Candlestick
Brass
English, early 19th century
H. 9⅝″ (24.5 cms)
M392–1917

Candlestick (one of a pair)
Nickel brass alloy (paktong)
English, c1770
H. 11½″ W. 4¾″ (29.3 × 12 cms)
M675–1926

By the late 17th century the design of brass candlesticks began to imitate those in silver. Thence forward, it is easier to date accurately and positively attribute national origins by comparison with fully marked silver examples. Technical improvements in the casting of both base and precious metal candlesticks also substantially altered their form.

Throughout the 18th century, the most popular method of production was to cast the entire socket, stem and base in two halves and subsequently solder the two together. On brass candlesticks which have been vigorously cleaned the two stems running vertically down the 'stick' can be seen quite distinctly. This construction method made possible elaborately stepped bases and octagonal faceted stems *(centre)*. By the middle of the century, the base had been simplified; it was often octagonal with a depressed centre, which had been fashionable in the late 17th century, but now the corners were concave and the stem of tall proportions *(left)*.

By the mid 1760s, neo-classicism was popular *(right)*. The characteristic shape for candlesticks was a straight or tapering column on a raised square or oval base. Later, beaded, engraved and relief ornament was added, and neo-classical types probably continued to be made in brass long after they had ceased to be popular in silver. Production of these candlesticks was even further simplified by the development of casting the stem in one piece using a removable core. This allowed for a much finer and thinner casting to be made for both the base and the stem.

This new technique also encouraged the development of a polyfaceted candlestick in the early 19th century, which was only made in brass. Although apparently heavy, they are in fact very light to handle *(second from right)*. By the middle of the 19th century, candlesticks were becoming superseded by oil lamps, which had been vastly improved by various patents in the earlier part of the century.

Candlesticks of paktong, an alloy with a proportion of zinc and imported from China, make an occasional appearance in the 18th century. Intended as a silver substitute, it was expensive and required skilful working. Thus it was never very popular.

The use of hollow-core castings changed the method of extraction of the stump. The most frequent method of removal in use from the early 18th century onwards was a push-rod extractor which consisted of a disc in the nozzle connected by an iron rod passing through the hollow stem to a brass button under the base *(second from left)*.

PLATE 25
Snuffers and stand
Brass
English, early 18th century
Snuffers L. 5¼″ (13.4 cms)
Stand H. 5⅛″ W. 3¼″ (13 × 8.3 cms)
M881–1926

Snuffers and tray
Brass, formerly silvered
French, 18th century
Snuffers L. 6½″ (16.5 cms)
Tray L. 10⅛″ H. 1″ (25.7 × 2.6 cms)
M671–1926

Snuffers and tray
Brass
English, late 17th or early 18th century
Snuffers L. 6¼″ (15.9 cms)
Tray L. 9⅝″ W. 2¾″ (24.5 × 7 cms)
M216 and a–1939

Snuffers
Brass
Flemish or German, 17th century
Stamped with an unidentified maker's mark of two
harness bells.
The scene stamped on the upper cover is of Adam
and Eve.
L. 8¼″ (21 cms)
M2080–1855

Taper stand
Brass
English, second half of the 18th century
H. 5¼″ (13.4 cms)
588–1883

Snuffers were an essential item of equipment in
connection with the burning of candles until the
invention, in the early 19th century, of a plaited
wick which burned sufficiently rapidly to keep it at
a short uniform length. They are essentially
scissors with a box attached to hold the ends of
charred wicks. One of the earliest types has a
container on each blade which closes to make a
heart shaped box (*right foreground*). These could
often be highly decorated.

By the 18th century, those in brass had become
stereotyped, and they were invariably cast. One
blade had a semi-rectangular or semi-circular box,
the other having a flat press which carried the cut
wick into the box and extinguished it. The spike
protruding beyond this box was used for uncurling
the wick before cutting. Various patents for
mechanical snuffers were taken out during the 18th
century which intended to prevent the short wick
ends falling out as the blades opened, but they
applied to versions in cut steel or Sheffield Plate
rather than in brass.

There is some variety evident in the stands for
snuffers. In the early 18th century there was a
fashion for supporting these instruments vertically
in a stem on a base which closely corresponded to
those for contemporary candlesticks. Otherwise
trays were used in which the snuffers were laid
flat.

PLATE 26
A pair of Day's patent chimney ornaments
Brass, partly lacquered black
English, Birmingham, about 1820
A label underneath reads: 'B Day's patent chimney
ornaments to represent Gothic Architecture are so
constructed that they may be used for firescreens,
flower or scent jars, timepiece cases, candleshades,
and various other useful purposes. Manufactured
by Patentee Snow Hill Birmingham . . .
Appointed manufacturer to his Majesty. The
portability and elegance of these Fire Screens give
them a decided preference to all others'.

The shaft is telescopic and once contained a
circular silk screen which could be fixed to the
finial.
H. 22¼″ W. 6¼″ (56.5 × 16 cms)
M64 and A–1967

A table gas lamp (Centre)
Gilt brass and Ceramic
English (Birmingham), about 1848
Made by R. W. Winfield, the design was registered
on February 16, 1848
H. 12½″ (31.8 cms)
M20–1974

Ornaments of this type were derided by A. W. N.
Pugin in his *True Principles of Pointed or Christian
Architecture*, London 1841, and one is illustrated in
Plate 24, entitled patterns of Brummagen Gothic
but despite the disapproval of such critics these
products were nonetheless popular.

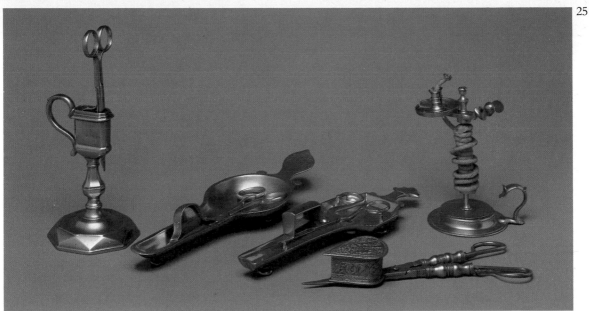

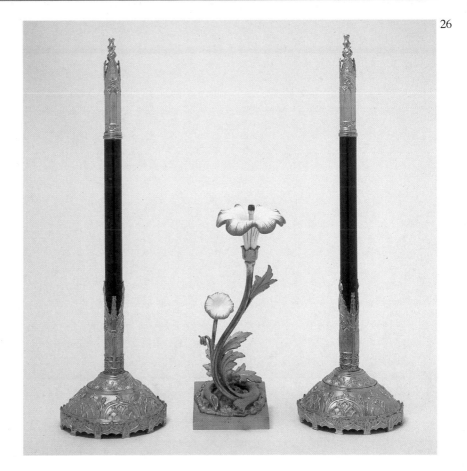

PLATE 27
Candelabrum
Brass
Made by John Hardman and Co, Birmingham
Designed by A. W. N. Pugin for the House of
Lords, c1846
Bought from the Great Exhibition, 1851
H. 27″ W. 18″ (71 × 45.7 cms)
M2740–1851

A pair of candlesticks
Gilt Brass
Birmingham, 1844–5
Designed by A. W. N. Pugin as part of a set for
use in the house built for himself at Ramsgate.
Made by John Hardman and Co, Birmingham.
A similar pair were exhibited in the Medieval
Court of the Great Exhibition in 1851.
Bought from the Handley-Read Collection
H. 13⅝″ Diam. 6½″ (34 × 17 cms)
M35 and a–1972

Candelabrum
Brass
Made by John Hardman and Co, Birmingham
Designed by A. W. N. Pugin
Bought from the Great Exhibition of 1851
H. 33″ W. 18″ (83.5 × 45.7 cms)
M2742–1851

PLATE 28
The Elkington pattern book.
A page illustrating some of the designs available in
brass
Birmingham, c1870
H. 20½″ W. 13¾″ (52 × 35 cms)

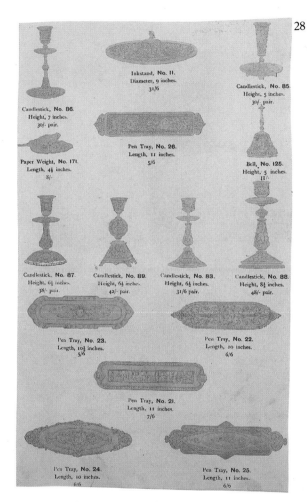

28

45

PLATE 29
Bath taps
Copper and Silvered, Britannia Metal
English, about 1900
H. 11″ W. 14½″ (30 × 37 cms)
Circ 191–1963
Design E717–1976

Designed by Nelson Dawson and made in his
workshops for William Frederick Danvers Smith,
1st Viscount Hambledon, a senior partner in the
firm of W. H. Smith and Sons for whom Dawson
made several designs. This bath unit was installed
in Lord Hambledon's house, Greenlands, near
Henley-on-Thames. The library at Greenlands,
now a civil service staff college, contains other
fittings designed by Dawson.

The black and white illustration is a design by
Nelson Dawson for this unit and is dated May
1900.

29

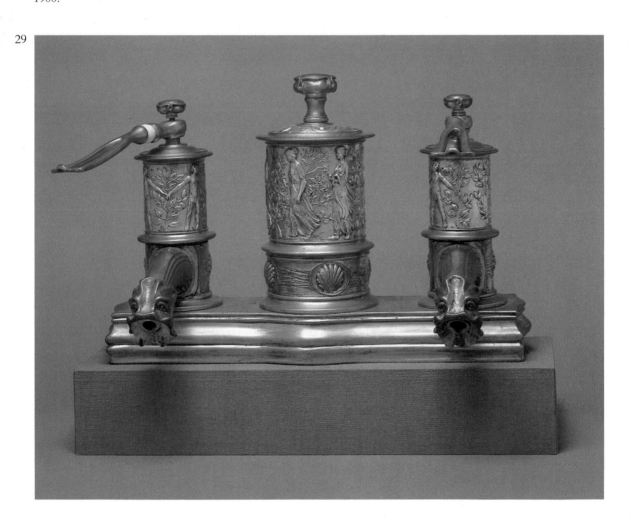

PLATE 30
Two handled bowl
Gilt Brass
Austria, Vienna (Wiener Werkstätte) c1920
Designed by Josef Hoffmann
Stamped with the monograms of the Wiener
Werkstätte, that of Josef Hoffmann and of the
craftsman who made the piece.
H. 7¼″ W. 11½″ (18 × 29 cms)
M41–1971

30

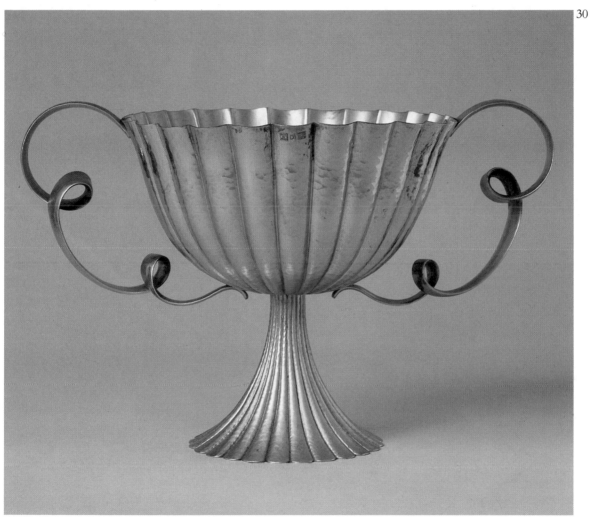

Further Reading

Brass, despite its popularity as a material, has been a largely neglected subject.

Hans Ulrich Haedeke's *Metalwork*, Weidenfeld and Nicolson, 1970 provides an excellent social history of the base metalwork trades in Europe, from the Romanesque period to the early 20th century, relating social history to the stylistic development of the objects described.

Seymour Lindsay's *Iron and brass implements of the English house*, Alec Tiranti, 1964 provides a well researched and readable account of domestic utensils and their functions.

English domestic brass, 1680–1810 by Rupert Gentle and Rachael Feild, Pan/Elek, 1975 contains much interesting information on the genesis and development of the English brasswork industry. Although the text is presented in a way that may not appeal to the general reader, the photographic coverage (particularly of mid-18th century brasswork) is excellent.

The standard work on Matthew Boulton and the Birmingham brasswork industry is Nicholas Goodison's *Ormolu: the work of Matthew Boulton,* Phaidon, 1974. The author's treatment of Boulton's marketing procedures is invaluable.

Candlesticks were the most popular of brass objects. Two authoritative histories are *Domestic candlesticks from the fourteenth to the end of the eighteenth century* by Alexander Curle, Edinburgh, 1926, and R. F. Michaelis's *Old domestic base-metal candlesticks from the 13th to 19th century,* Antique Collectors' Club, 1978. The former was a privately printed publication by the Society of Antiquaries of Scotland, and copies are generally elusive. Michaelis, however, incorporates and acknowledges much of Curle's information. Another reference for candlesticks is 'Domestic Brass Candlesticks 1450–1850' by Michael Snodin in the *Antique Dealer & Collector's Guide*, July 1976.